FANTASTIC CITIES AND OTHER PAINTINGS

Fantastic Cities

AND OTHER PAINTINGS BY

Vera Stravinsky

David R. Godine, Publisher · Boston

First published in 1979 by David R. Godine, Publisher
306 Dartmouth Street, Boston, Massachusetts 02116

ISBN 0-87923-264-1 (hardcover), 0-87923-265-x (softcover)

LCC 78-68138

Printed in the United States of America

CONTENTS

ABOUT VERA STRAVINSKY'S PAINTINGS

EUGENE BERMAN

Vera Stravinsky is a singularly lucid and sensitive artist, sure in her thought and able in her hands. She knows for what she is searching and what she finds is rare and happy. Her enthusiasm is youthful but it is tempered by a very sure instinct and a natural wisdom. Her paintings are delicate, fresh, full of enchantment.

PAUL HORGAN

When we look at Vera Stravinsky's paintings we often feel as we would if something or a place we know well were suddenly shifted a few inches into a new air, revealing a face of things we never suspected but at once receive with pleasure. The intuitions and illuminations of her work are essentially feminine, as strong and elegant as she is in life. To carry the originality of her vision, she has a freshness of technique, matching her discoveries of the secret facts of the familiar.

There are recent works (1976–1977), less abstract than the earlier, which create a long series of imagined cities with towers, banners, palaces, esplanades, harbors, anchored ships, floating between infinite sky and formal waves of the sea. Their colors are brilliant in high contrasts and delicious harmonies. These works are revelations of a special world which Vera Stravinsky carries within herself. It is a world like that of no one else, but it can be ours, because she has the power to make an eternally youthful and joyous fantasy as true for us as it is for her.

ALDOUS HUXLEY

Fantasy in painting is of many kinds and runs the whole gamut, from dramatic and symbolic imagination at one end of the scale to purely formal imagination at the other. The imagination which animates Vera Stravinsky's work lies somewhere between the two extremes and partakes, in some measure, of both. At the formal end of the scale, she possesses a wonderful gift for inventing coloured patterns; but this gift is combined with another, the gift of transforming her formal inventions into an amused and amusing commentary on the realities around her—an oilfield, for example, a fishbowl, a boulevard at night with all its headlamps and neons. She sees the heavenly oddity in things, she is touched by their absurd and pathetic loveliness; and she proceeds to render these aspects of reality, not directly, not in terms

of impressions caught on the wing and recorded in calligraphic shorthand, but at one remove, through what may be called their visionary equivalent. This visionary equivalent of the world's preposterous beauties is a specially created universe of flat houses, depthless landscapes, two-dimensional aquariums—a private universe, where the colours glow with praeternatural brilliance (and an infallible good taste), where the darks are like lacquer and the lights like so many small apocalypses from another world of angelic gaiety and paradisal enjoyments. Hers is a happy art, and, as Jeffrey once ventured to tell Carlyle, 'You have no mission on earth (whatever you may fancy) half so important as to be innocently happy.' In these paintings Vera Stravinsky has certainly done her duty and fulfilled her mission.

CHRISTOPHER ISHERWOOD

Vera Stravinsky's kind of painting is as revealing as handwriting. Those who practice it risk being self-unmasked as fakers, phony clairvoyants, camoufleurs of their inner emptiness. But Vera Stravinsky's own pictures have the authority of absolute sincerity and genuine visionary experience. She paints with a radiant good humor and poetic joy, and so unselfconsciously that you might suppose she does it in her sleep. Indeed, there is a quality of dream-magic in her work. Like dreams, these pictures can often be interpreted in a variety of ways. Are those shapes skyscrapers on the waterfront of a harbor? Are these the lagoons of Venice? Is this the South Pole? Yes—if you like; if you want it to be so. Vera Stravinsky will not object. And yet her vision remains, as something apart from and more exciting than any interpretation. If you live with her paintings for a while, I think you will begin to find in them an element which eludes verbal description—an intimation of happiness.

STEPHEN SPENDER

It will surprise no one who sees the paintings of Vera Stravinsky that these are the works of an artist who was a ballerina and associated with the famous Russian ballet of Diaghilev. Her paintings emerge from that legendary world in which floating forms dissolve into light and rhythm. A picture which seems to be of a bouquet consisting partly of flowers and partly of the wings and tail feathers of exotic birds resembles also the convergence of the ballerinas in a performance of 'Swan Lake,' into a cluster which poignantly evokes the fragility and transience of human flesh in transparent colours, shifting lights and almost impalpable substances. Her paintings always suggest dance, transformations, which while changing are transfixed by the artist at some moment of uttermost charm. The turrets and battlements of cities in her work are from Russian scenes on Russian stages. Yet sometimes her particular way of dramatizing or choreographing can be trans-

ferred to a quite different situation. For example, a stretch of the Californian coast is seen at night with lights which are jewels giving off white, gold, sapphire and emerald rays. Here the artist makes vivid for us one of those rare moments (like the vision passengers have of beams from the headlights of cars and street-lighting seen at night from an aeroplane) in which the modern world seems suddenly magical. Through all Vera Stravinsky's work there shows the delight in living (this includes a sense of the tragic) of an entrancing personality. In the best of these pictures a vision of life as changing and transient, created by a sensibility of poetic radiance, seems to have brushed off from her own personality onto the paper: as though the dust off the wings of some wonderful butterfly were to be used as the colours of images as beautiful as the butterfly itself. These pictures are pages from an album which goes back to the Russian ballet of the early years of this century and forward to the great feast which was the life and works of Igor Stravinsky.

THE PAINTINGS

The paintings are in gouache unless otherwise stated.
Dimensions are provided first in inches, then centimeters, with height preceding width.

· I ·

OILFIELD

$20\frac{1}{4} \times 17\frac{3}{16}$ (51.4×43.7)

(OIL)

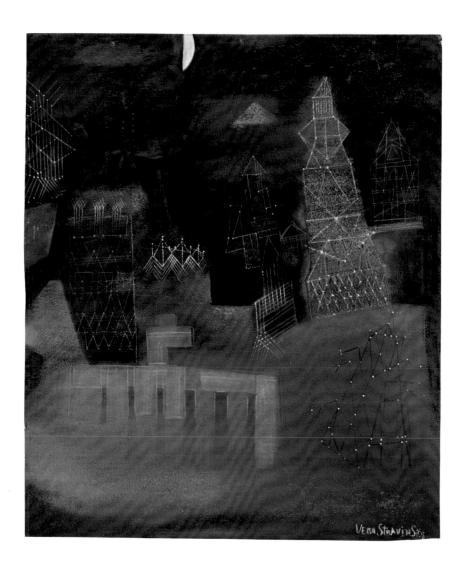

· 2 ·

FANTASTIC CITY

$11 \times 15\frac{1}{8}$ (28.0 × 38.5)

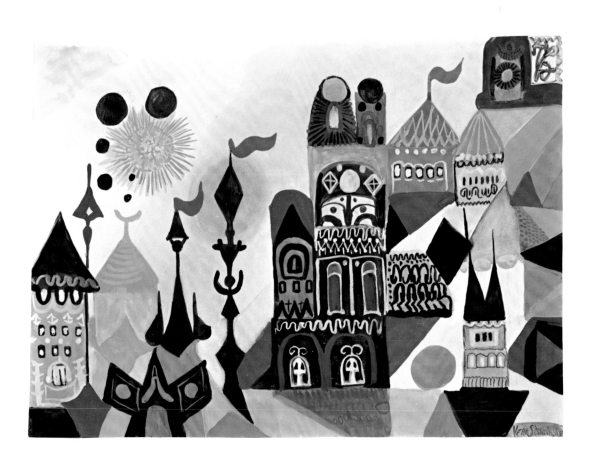

· 3 ·

FANTASTIC CITY

11 1/16 × 14 1/2 (28.1 × 36.8)

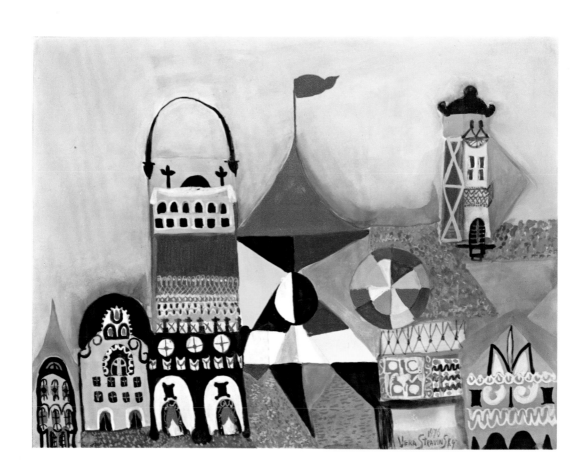

· 4 ·

FANTASTIC CITY AT NIGHT

$12\frac{7}{8} \times 14\frac{11}{16}$ (32.7 × 37.3)

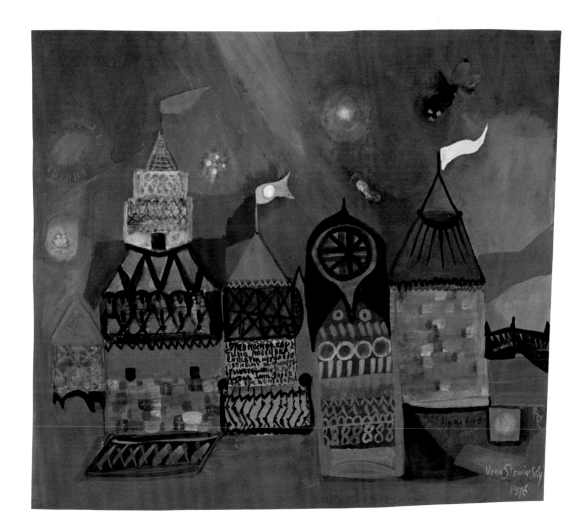

· 5 ·

LANDSCAPE

11 × 13¾ (27.9 × 34.9)

(COLLAGE)

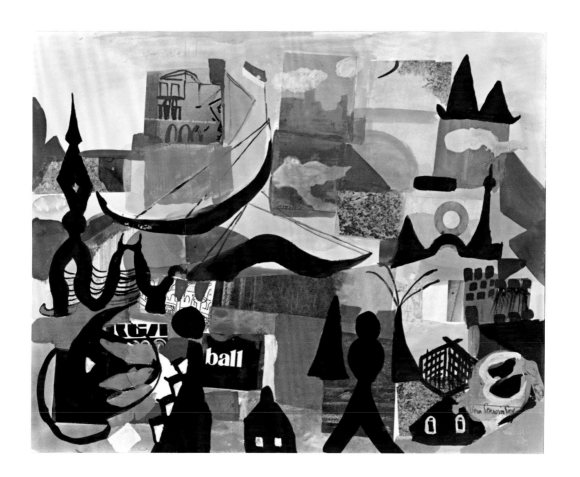

· 6 ·

LANDSCAPE WITH BOAT

11 1/16 × 13 1/2 (28.1 × 34.4)

(COLLAGE)

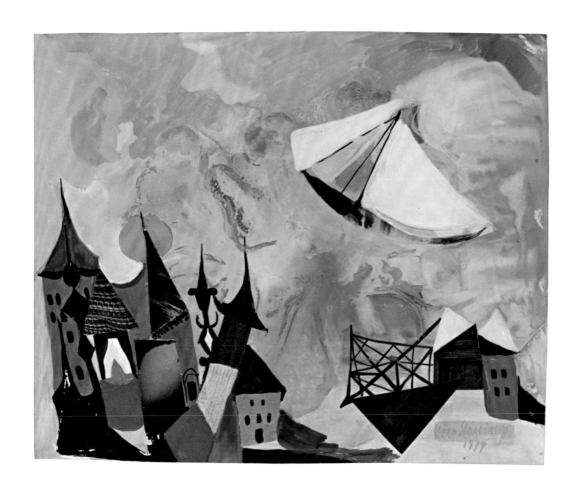

· 7 ·

FANTASTIC CITY

$7^{11}\!/_{16} \times 10^{11}\!/_{16}$ (19.5 × 27.2)

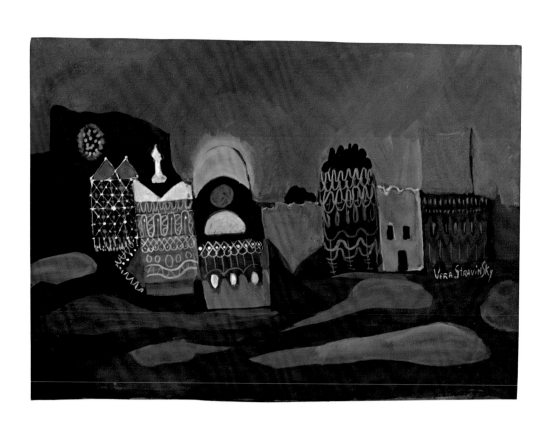

· 8 ·

FANTASTIC CITY

$7\frac{1}{8} \times 11\frac{1}{16}$ (18.1 × 28.1)

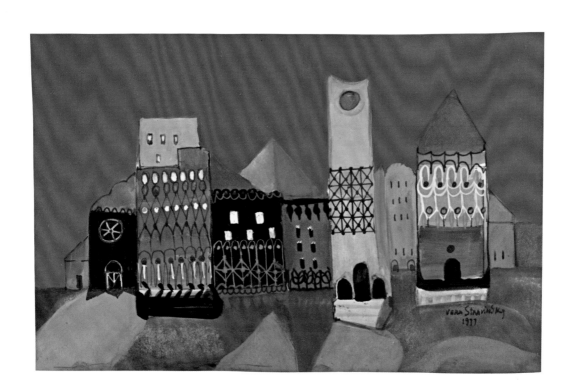

· 9 ·

FANTASTIC CITY

$7^{5}/_{16} \times 10^{15}/_{16}$ (18.6×27.8)

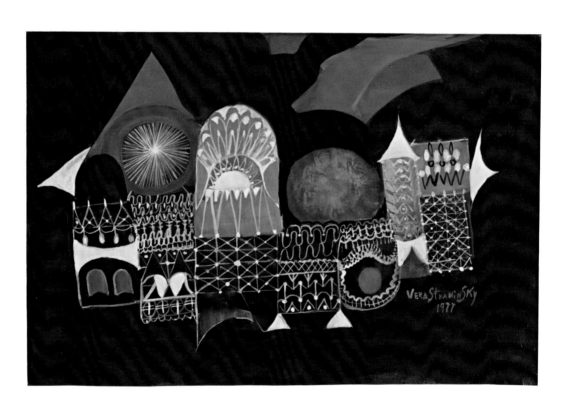

· IO ·

CITIES IN WATER

$9\frac{7}{8} \times 12\frac{1}{4}$ (25.1 × 31.2)

· I I ·

CITIES IN WATER

9½ × 14⁹⁄₁₆ (24.1 × 37.0)

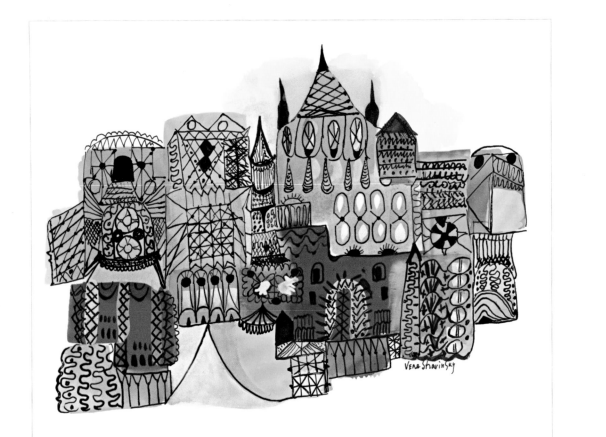

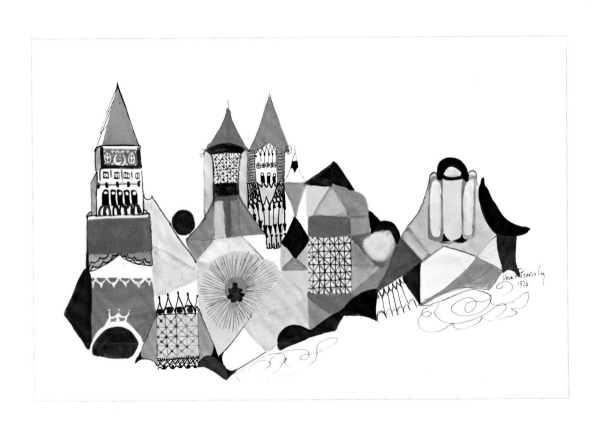

· 1 2 ·

CITIES IN WATER

9 × 14½ (22.8 × 36.8)

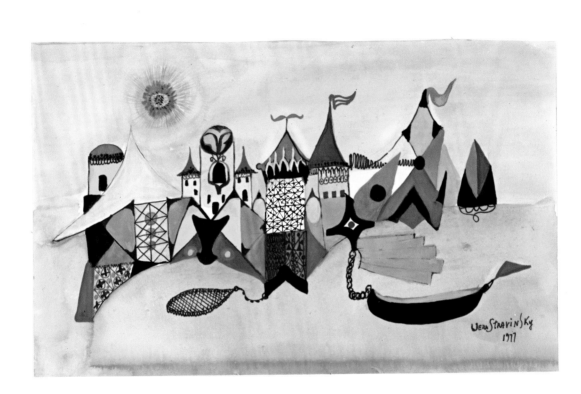

· 13 ·

ABSTRACT

11¹⁄₁₆ × 14¾ (28.2 × 37.6)

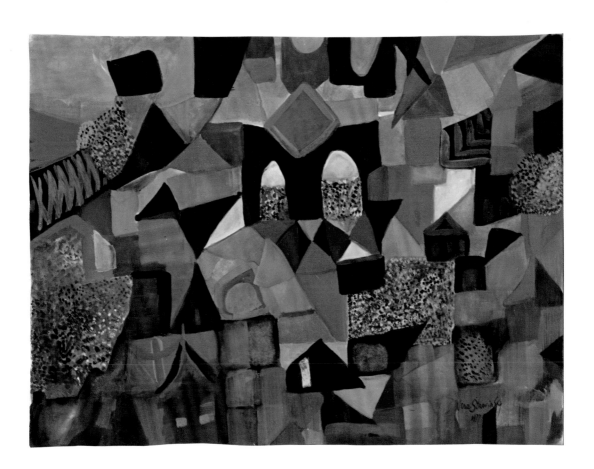

· 14 ·

DECORATION

$6^{11}/_{16} \times 9^{5}/_{8}$ (17.0×24.5)

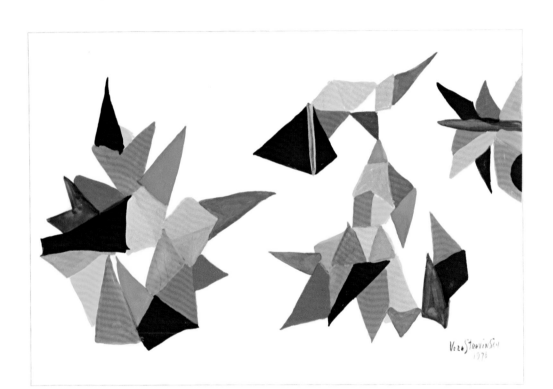

· 15 ·

ABSTRACT WITH LINES

$8^{15}/_{16} \times 11^{11}/_{16}$ (22.7 × 29.7)

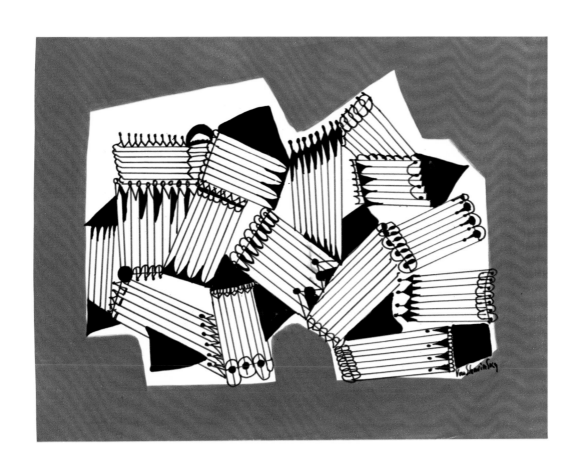

· 16 ·

BOUQUET D'AUTOMNE

$11\frac{1}{8} \times 9\frac{11}{16}$ (28.3 × 24.6)

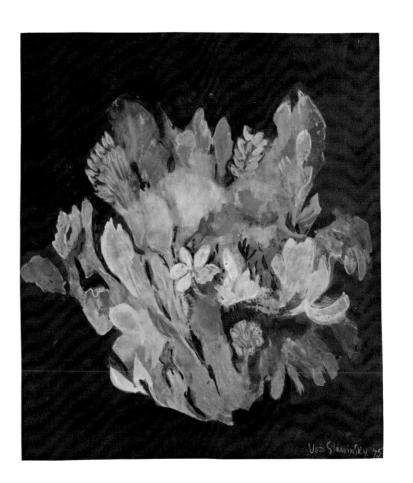

· 17 ·

BLUE LEAVES

$13 \frac{1}{4} \times 10 \frac{7}{8}$ (33.8×27.7)

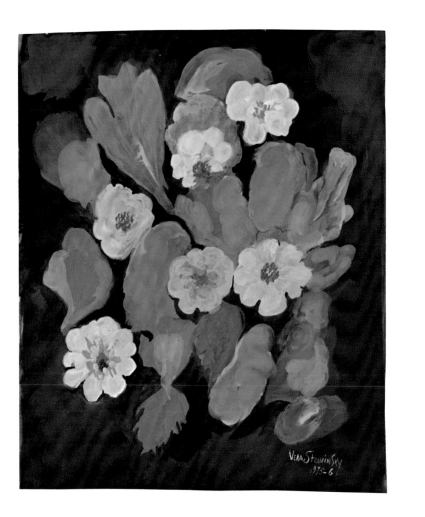

· 1 8 ·

FLOWERS

$7\frac{5}{16} \times 8$ (18.6 × 20.3)

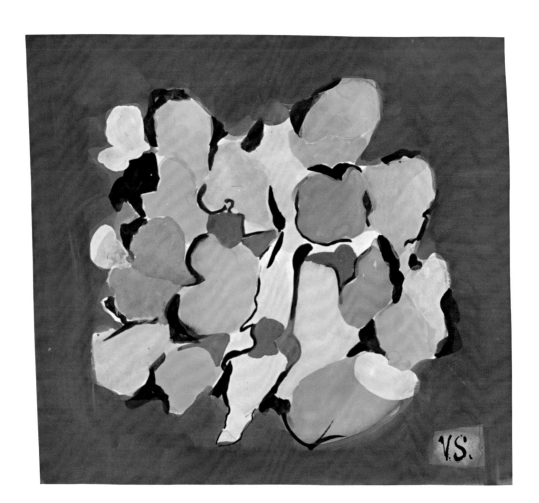

· 19 ·

FOR JIMMY

$8 \times 9\frac{3}{4}$ (20.3 × 24.8)

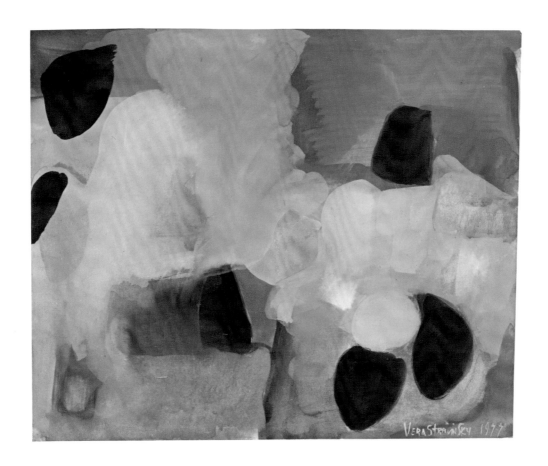

· 2 0 ·

EXPLOSION

$11\frac{1}{2} \times 13\frac{15}{16}$ (29.2 × 35.4)

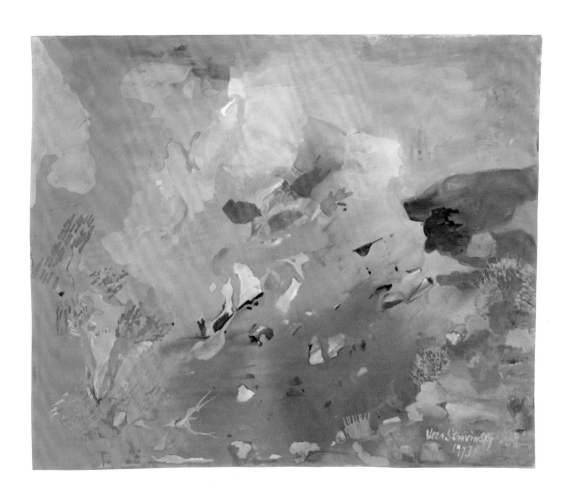

· 2 I ·

BEGINNING OF WINTER

$10^{11}/_{16} \times 12^{1}/_{2}$ (27.2 × 31.7)

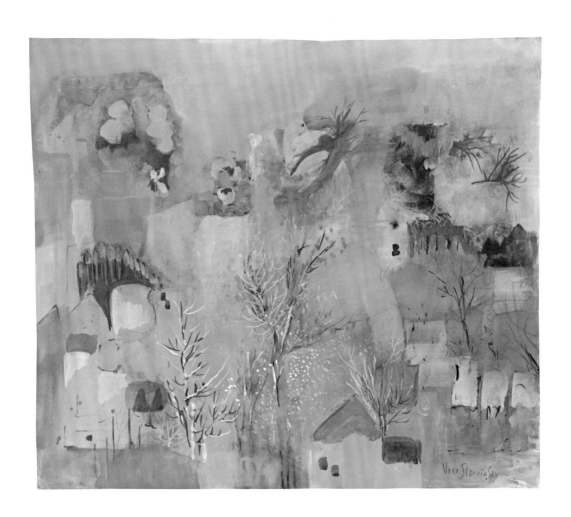

· 2 2 ·

FOR OPHELIA

$10^{7}/_{16} \times 14^{7}/_{16}$ (26.5 × 36.7)

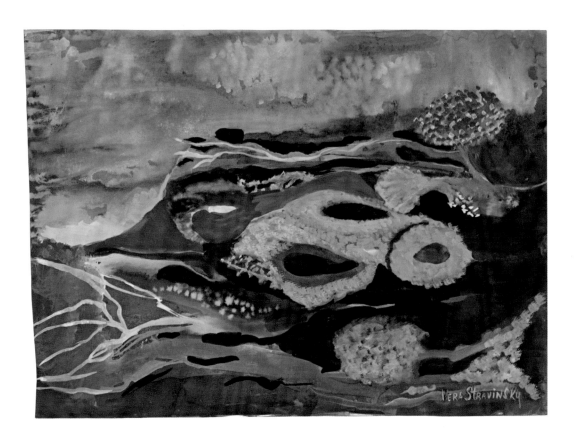

· 23 ·

MALIBU BEACH

$10\frac{7}{8} \times 13\frac{11}{16}$ (27.6×34.8)

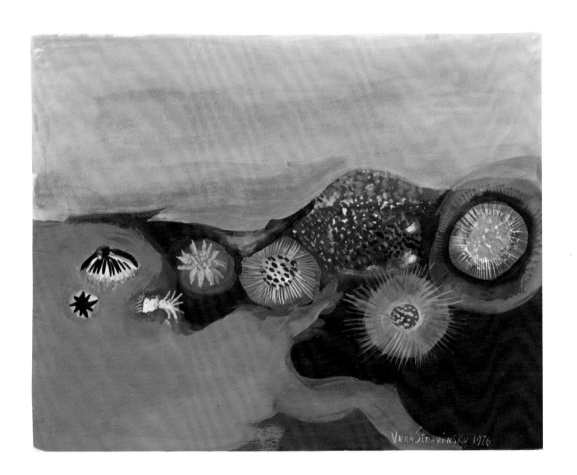

· 2 4 ·

UNDERWATER

11 × 13 ⅝ (27.8 × 34.5)

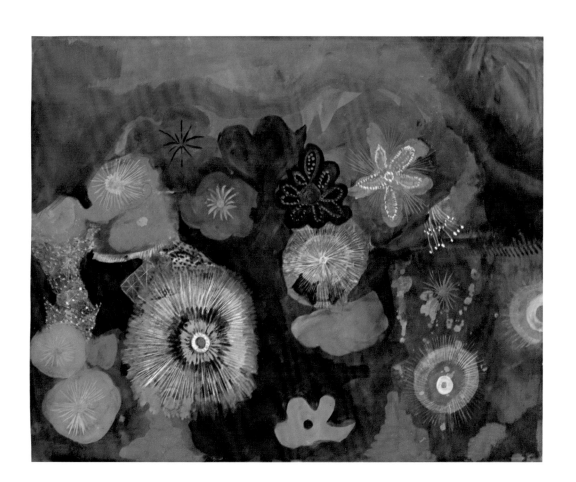

· 2 5 ·

SHELL ON ORANGE

8⁵⁄₁₆ × 10¼ (21.2 × 26.1)

(OIL)

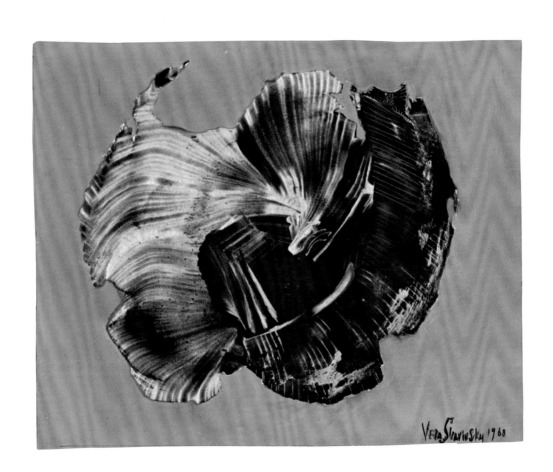

VeraStravinsky 1968

December 25, 1888

Vera Arturovna de Bosset is born at Aptekarsky Ostrov, Pesochnaya Ulitsa, 5, St. Petersburg, the home of her parents, Artur de Bosset and Henriette Malmgren. At about 1900, one of Mme de Bosset's brothers, the cellist Eugene Malmgren, employs the young Igor Stravinsky as piano accompanist.

1890–1902

The de Bosset family lives in Bougri, near St. Petersburg, during Vera's infancy, and for the next twelve years in their country estate at Gorki, in Novgorodskaya Province, mid-way between Moscow and St. Petersburg, where Vera is educated by governesses. In 1902 the family moves to Kudinovo, near Moscow, where Artur de Bosset owns Russia's largest electrical equipment factory. Vera attends the Pussell boarding school in Moscow. She studies music, becomes an accomplished pianist, and discovers her vocation as an actress. Her primary interest is in the theater, where she is deeply impressed by the productions of Stanislavsky, and by the performances of Bernhardt, Duse, Isadora Duncan.

1910–1912

Vera de Bosset enters the University of Berlin as a student in philosophy, science, and anatomy. Switching to an art curriculum in her second year, she attends Heinrich Wölfflin's lectures in art history, and those of Wirchow in anatomy. In November 1912, she sees Diaghilev's Ballets Russes during its first Berlin engage-

ment. She meets Robert Shilling, a Balt, and, after returning to Moscow, marries him.

1913–1914
As a pupil in the Nelidova Ballet School, Vera Shilling meets Serge de Diaghilev and Michel Fokine during Diaghilev's last visit to Russia in search of dancers.

1914–1916
Vera Shilling is engaged as an actress at the Kamerny Theater. She plays in films—one of her partners is Marius Petipa (the son of the choreographer of *Swan Lake*)—and her most important role is that of Helen in Protozanov's *War and Peace*. In September 1915 she meets Serge Yurievitch Sudeikin. The following description of this episode is from Professor John Malmstad's chronicle of the life of the poet Mikhail Kuzmin:

. . . the Donna Anna of the [poem] is still alive and remembers well the events which the poem describes and also her association with her old friend Kuzmin, whom she vividly discussed in a memorable conversation with me in her New York apartment [Essex House, May 7, 1970]. She is Vera Stravinsky, widow of the composer. Before her marriage to Stravinsky she was the second wife of Sudejkin (after his separation from Glebova) and the poem itself describes their romance in the autumn of 1915. Thus the initials of the dedication are clear, standing for Vera Arturovna Shilling, née de Bosset, and Serge Jurievic Sudejkin. Then in her early twenties . . . Vera Arturovna was infatuated with the

theater and was especially interested in Tairov's Kamernyj Theater which had only recently opened in Moscow. Tairov learned of this interest and of her desire to join his company and paid her a visit. He came, as she frankly admits, because he had heard the rumors that her father was very wealthy . . . When he asked her why she wanted to become an actress she replied simply that she loved the theater. To his question about her previous experience she replied honestly that she had none and thought that she had little talent. Tairov invited her anyway, probably charmed by her beauty and determination. As her husband, Shilling, had no objection, she immediately accepted the offer. She began to attend the rehearsals of the company and remembers how Tairov jokingly liked to remark, punning on the title of an Ostrovskij play, '*u nas ne bylo ni grosa, da vdrug Shilling!*' The company was then rehearsing Beaumarchais's *Le Mariage de Figaro.* Sudejkin, in Moscow to design the sets and costumes, fell in love with the beautiful young woman. He was determined that she should have a part in the production. As she had had no experience but had studied ballet, Sudejkin and Tairov created a separate number for her, a Spanish dance for which the artist designed a special costume decorated with tiny stars. Thus the references in the poem to '*Ispanija i Mocart—"Figaro"*' are clear (Mozart was used for the incidental music), as are the references to the 'heroine's' '*ognennye i bystrye tancy.*' The references to Donna Anna, who, of course, does not appear in Mozart's *Le Nozze di Figaro* but in *Don Giovanni,* are also explainable. Sudejkin, who had immediately begun courting her, referred to himself throughout the courtship as Figaro but felt the name Susanna did not suit Vera Arturovna's special beauty. So he began to call her Donna Anna, but refused to allow her to address him as Don Juan, as he felt the Don unsympathetic. The romance began in September and continued throughout the autumn and winter. Their favorite place for rendezvous was the Kremlin, especially its great

cathedrals, and this too is reflected clearly in the poem (the Uspenskij and Blagovescenskij cathedrals are mentioned by name), as is even the black 'subka' she wore at the time . . .

Sudejkin had by then separated from Glebova and [on March 15] 1916 he and Vera Arturovna moved to St. Petersburg. At first they took an apartment immediately above the 'Prival komediantov.' Kuzmin was a frequent guest at the apartment and the three of them would sometimes stop into the cabaret to see friends. Kuzmin was much taken by the charm and intelligence of the young woman and was delighted by the story of the circumstances of their romance. He was especially intrigued by the fact that the romance had been played out against the background of the old Russia—the Kremlin, the oldest parts of Moscow—Vera Arturovna herself, considered by some, like Thomas Mann, to be a 'specifically Russian beauty,' had no Russian blood. Her father was of French descent, her mother Swedish. This Kuzmin referred to in the poem's conclusion . . . As a surprise Easter gift to her, he wrote the poem ('cuzaja' because it is the story of someone else's love affair and is told from Sudejkin's point of view), and presented her with a copy, dated '1916. April. Easter,' which is still in her possession. Kuzmin continued to see them often and inscribed several other poems to her, but he lost touch with them after the October Revolution when she and Sudejkin fled to the Crimea and from there to Europe. They never again heard from Kuzmin, and Vera Arturovna did not learn until our interview in 1970 that the 'poema' inspired by her had eventually been published. (From *M.A. Kuzmin Sobranie stikhotvorenij*, Fink Verlag, Munich, 1977)

1916

Petrograd. Anna Akhmatova draws a silhouette portrait of Vera de Bosset.

1917

Petrograd. Vera de Bosset hears Maxim Gorky speak. During the street fighting in March 1917, she suffers exposure, becomes seriously ill, and returns to Moscow. In June she moves to the Crimea, where, in Alushta, Osip Mandelstam writes one of his most famous poems for her, *Tristia* No. 3, which contains a description of her. Mandelstam gives the manuscript to her (August 11), and the manuscript of another of his poems. One of her closest friends during this period is Varvara Karinska ('Varinka' and 'Verinka'). Vera de Bosset completes pictures in petit-point.

1918

Yalta. February 11. Vera de Bosset marries Sudeikin. One of her paintings and twenty of her silhouettes on glass are included in the celebrated exhibition 'Art in the Crimea.' (A painting by Igor Stravinsky's sister-in-law is in the same show.)

May–August 1918

Miskhor. Mme Sudeikina's friends here include the painter Ivan Bilibin, who dedicates two poems to her (May 15 and June 3).

1919–1920

Tiflis and Baku. In Tiflis, the Polish artist Sigismund Valeshevski draws Mme Sudeikina's portrait. Serge Gorodetsky dedicates several poems to her, one of them dated 'Tiflis, May 23, 1919,' and also paints watercolor album portraits for

her of himself, Blok, Kuzmin, Balmont, Biely, Brussov, Remizov, Sologub. She meets Gurdjieff, who purchases two antique rugs from her when she and her husband move to Paris.

May 1920

The Sudeikins (and Sorin and Prince Melikov) sail for Constantinople and France on the *S.S. Souirah*, but a few hours after leaving Batum the passengers are robbed by Georgian pirates who have boarded the ship there. They relieve Mrs. Haskell, wife of the American Commissioner in Transcaucasia, of her diamonds, and all others of other valuables—except Mme Sudeikina, to whom the admiring buccaneer chieftain gives a talisman louis d'or. (The bandits landed at the Turkish port of Riza; they were later caught by a French destroyer and tried for piracy in Marseilles.)

May 20, 1920

The Sudeikins arrive in Paris, the Hotel Médical, 26, rue du Faubourg St. Jacques, and are aided by Russian refugee friends including Alexei Tolstoy and many members of the Ballets Russes, Diaghilev first among them, Sudeikin having been a founding member of *Mir Isskustva*.

August 10, 1920

Konstantin Balmont dedicates a poem to Mme Sudeikina. Before the end of the

year the Sudeikins move to the Elysée Hotel, 100, rue de la Boétie (according to a letter to Sudeikin from Nicolas Roerich in New York).

1921
The Sudeikins move to an apartment in the Boulevard Perer.

February 19, 1921
Serge Diaghilev introduces Mme Sudeikina to Igor Stravinsky.

March 1921
Stravinsky writes the first theme of *The Firebird* in Mme Sudeikina's autograph album, adding a dedication. Later he inscribes several measures from the Fourth Tableau of *Les Noces* in another album. Mme Sudeikina is injured in an automobile accident and Stravinsky composes a poem describing the event.

July 14, 1921
Igor Stravinsky and Vera Sudeikina count their wedding anniversaries from this date (as a note from the composer to his wife, July 14, 1966 reminds her).

September 1921
The Sudeikins move to an apartment in the rue Fremier.

November 2, 1921

London. The Alhambra Theater. Mme Sudeikina plays the role of the Queen in Diaghilev's revival of *The Sleeping Beauty*.

1922

Paris. Léon Bakst draws Vera Sudeikina's portrait (after March 23, according to a letter from Bakst describing his plans). In the summer she moves her Paris fashion accessories shop, the 'Tula Vera' (Tula Danilova, daughter of a high official at Tsarskoe Selo), to Deauville. The establishment reopens in Paris, 6, rue Euler, where, in 1924, she makes the costumes for the French stage premiere of *Histoire du Soldat*. On August 19 Sudeikin goes to America to fulfill commissions as a stage designer for the Metropolitan Opera, and Vera Sudeikina shares an apartment with Gabrielle Picabia (ex-wife of the painter) at 82, rue Petits Champs.

1923

Monte Carlo. Vera Sudeikina rehearses the part of the bride in *Les Noces* but is obliged to withdraw because of illness. Her portrait is painted by Sorin and by Jacovlev.

Mid–1920s

Vera Sudeikina becomes a costume advisor for Diaghilev, as well as his supervisor for the making of costumes at the Maison Verame, including those for Goncharo-

va's *Firebird* (November 1926), Marie Laurençin's *Les Biches*, and Rouault's *Le Fils Prodigue* (May 1, 1929). She designs and makes 300 costumes for a production of *Carmen* in Amsterdam, conducted by Monteux (November 17, 1928).

1933

Paris. Vera Sudeikina completes works in petit-point, notably a pillow portrait of her borzoi. She studies English with Serge Nabokov, brother of Vladimir.

January 1940

Vera Sudeikina sails on the *S.S. Rex*, Genoa to New York. On March 9, in Bedford, Massachusetts, she marries Igor Stravinsky. They live in Boston until May, then move to California and go to Mexico, re-entering the United States on August 8 as Russian Non-Preference Quota Immigrants.

August 30, 1945–1946

Vera Sudeikina and Lisa Sokoloff found and direct the Beverly Hills art gallery, 'La Boutique,' which gives exhibitions of pre-Columbian sculpture, of Picasso, Klee, Chagall, Dali, Tchelitchew, Berman, as well as Mrs. Stravinsky's creations of bouquets of flowers made of rice paper; bouquets made of rare old fabrics and beads placed in tiny vases; stones painted and decorated with sequins; dried sponges; irridescent butterflies in glass boxes.

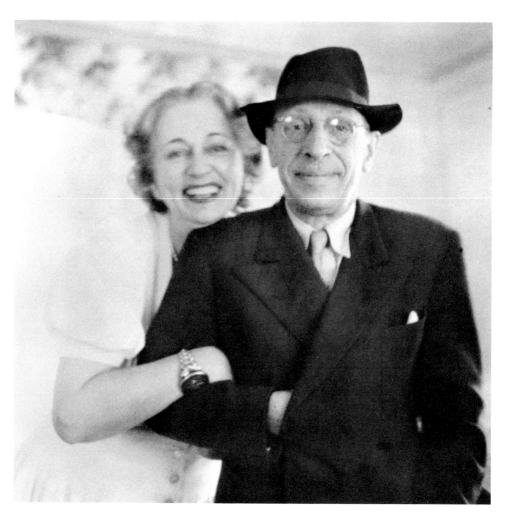

New York 1948

October–November 1945

Vera Stravinsky's 'Madonnas,' collage pictures made of fabrics, jewels, beads, sequins, and other materials are exhibited at the Pasadena Art Institute. The Pasadena *Star-News and Post*, October 28, 1945, quotes Mrs. Stravinsky: 'One day in early autumn in central France, I went . . . to a village. The people were bringing back the statue of the Madonna from the mountains, where she had been taken to protect the cattle during the summer. The people changed all of her clothes, and dressed her in lace, embroidery, jewels, and a crown . . . About ten o'clock at night the procession came down from the mountains. In the church everyone paid homage to the beautiful Madonna, some dancing, others playing music.'

1949

Mrs. Stravinsky resumes her career as a painter, working for several years before giving her first one-woman show.

Exhibitions include:

Galleria Obelisco (Rome)	April 1955 and November 1958
Galleria del Sole (Milan)	April 20–May 1955
Santa Barbara Museum of Art	February–March 1956
Los Angeles County Museum (group show)	May 1956
Alexander Iolas Gallery (New York)	January 1957
Knopp-Hunter Galleries (Sante Fe)	July 1957

Cushman Gallery (Houston)	January 1958
Comara Gallery (Los Angeles)	June 1958 and June 1960
Galleria D'Arte Del Cavallino (Venice)	September 1958
Matsuya Gallery (Tokyo)	April 1959
The Shop (Santa Fe)	July 1960
The Shop (Sante Fe): this show included twelve of Mrs. Stravinsky's needlepoint rugs.	July 1961
Galeria Diana (Mexico City)	April 1961
Galerie Internationale (New York)	May 1–14, 1962; December 1963; December 1964
Tel-Aviv Museum, Dizengoff House	September 1962
Brooklyn Museum (group show)	1963
Closson Gallery (Cincinnati)	March 1964
The Chelsea Bank (New York)	November 1971
Jose Nuñez Gallery (Washington, D.C.)	February 1972
Rizzoli Gallery (New York)	June 1972
Saratoga Performing Arts Center	July 1972
The Leonard Hutton Galleries (New York)	May 1973
The Crane Kalman Gallery (London)	March 1978

In November 1967, the Guggenheim Museum purchased one of Mrs. Stravinsky's red gouache abstractions.

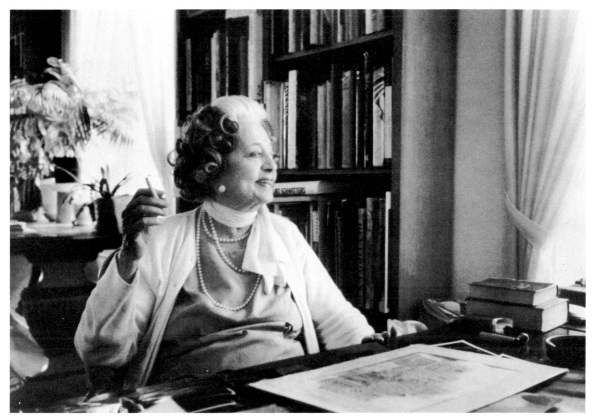

New York 1977

Photograph by Gjon Mili